MEN
&
CATS

Marie-Eva Gatuingt *and* Alice Chaygneaud

A PERIGEE BOOK

PERIGEE
An imprint of Penguin Random House LLC
375 Hudson Street, New York, New York 10014

MEN & CATS

ISBN: 978-0-399-17585-5

First edition: September 2015

PRINTED IN THE UNITED STATES OF AMERICA

10

Most Perigee books are available at special quantity discounts for bulk
purchases for sales promotions, premiums, fund-raising, or educational use.
Special books, or book excerpts, can also be created to fit specific needs.
For details, write: SpecialMarkets@penguinrandomhouse.com.

Since we started our Tumblr, *Des Hommes et des Chatons*, in 2013, thousands of fans have discovered the allure of pairing sexy men with cute cats in strikingly similar poses. Now we have combined the crème de la crème into one volume with fifty never-before-seen man and kitty couples.

Men & Cats will remind you that your favorite things are even better when paired together.

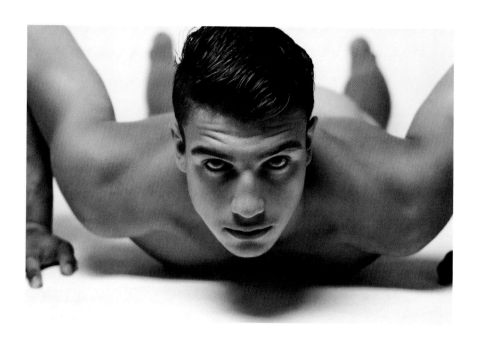

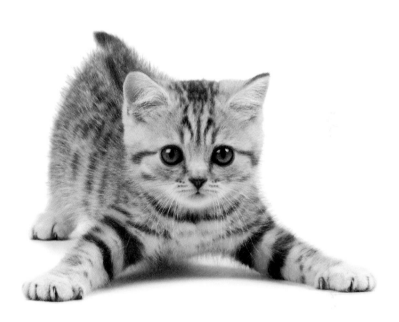

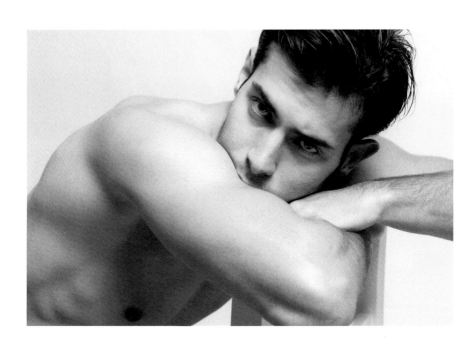

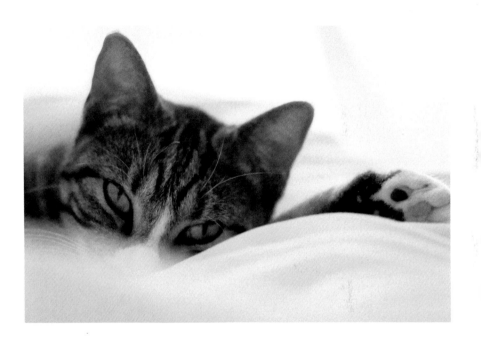

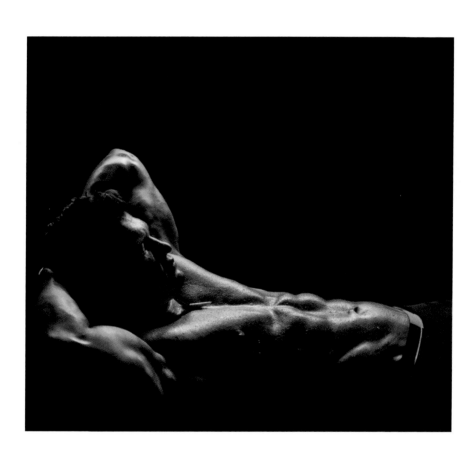

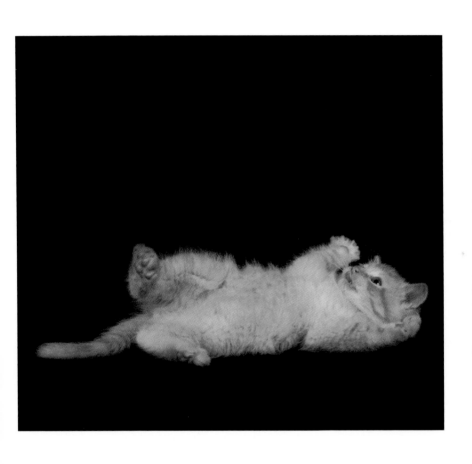

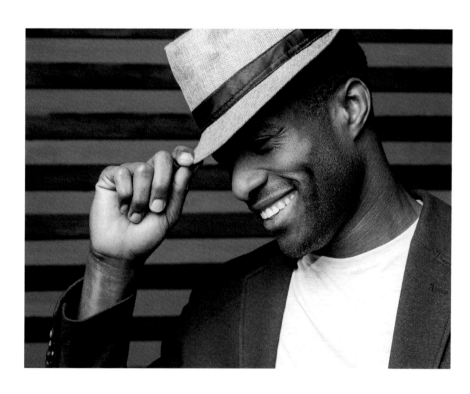

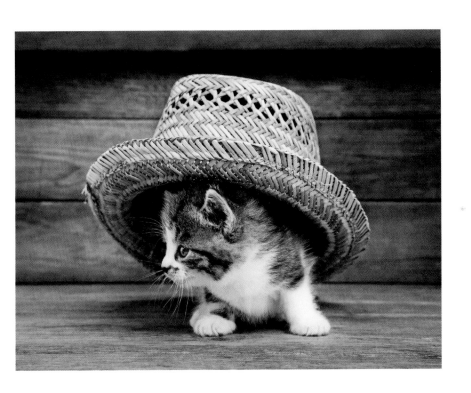

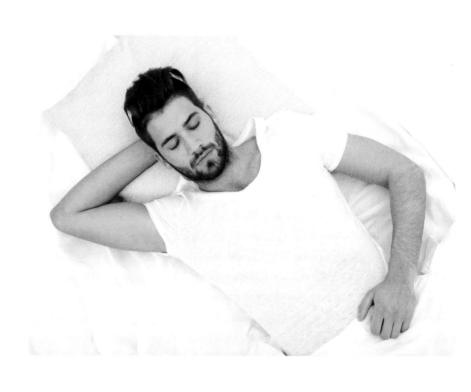

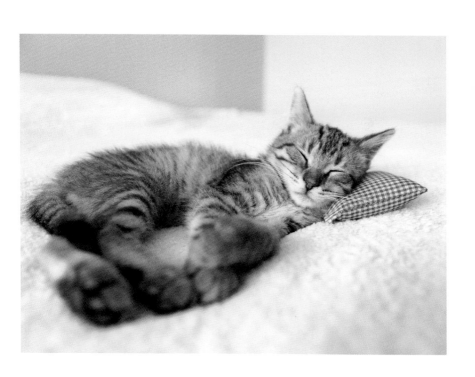

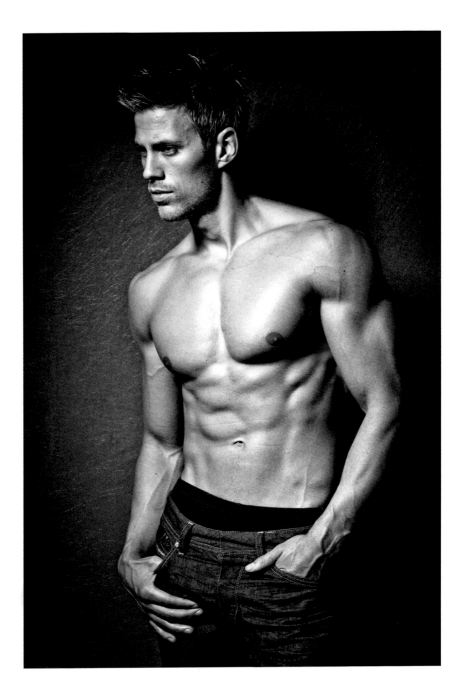

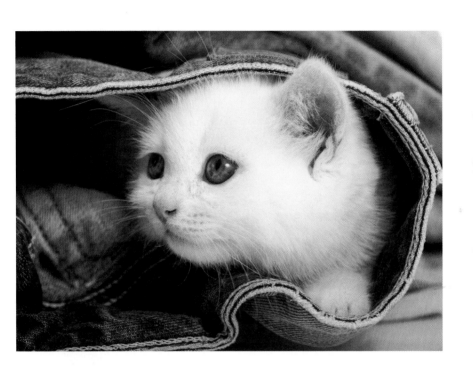

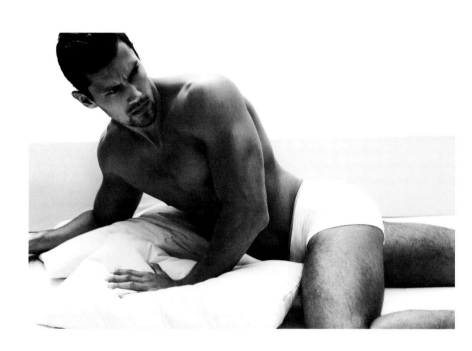

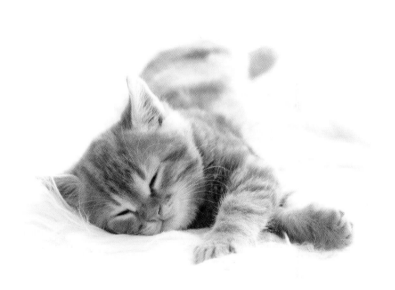

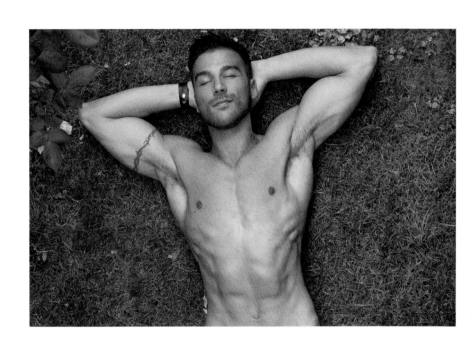

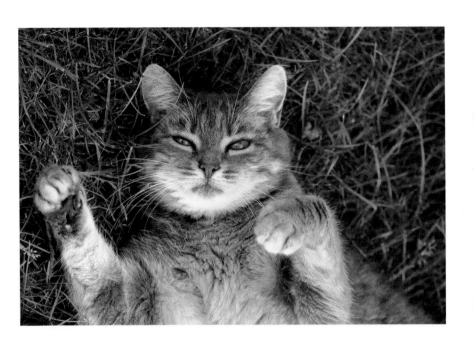

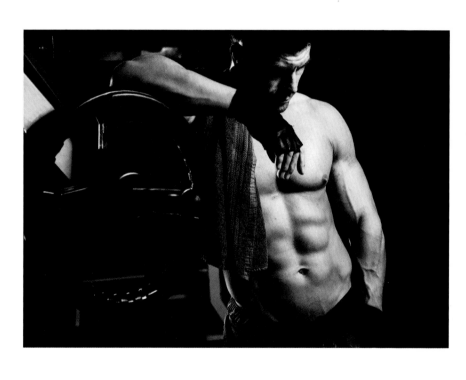

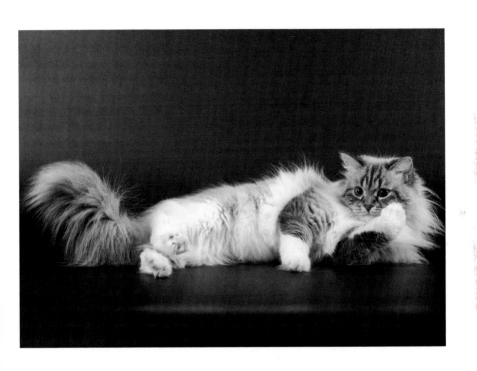

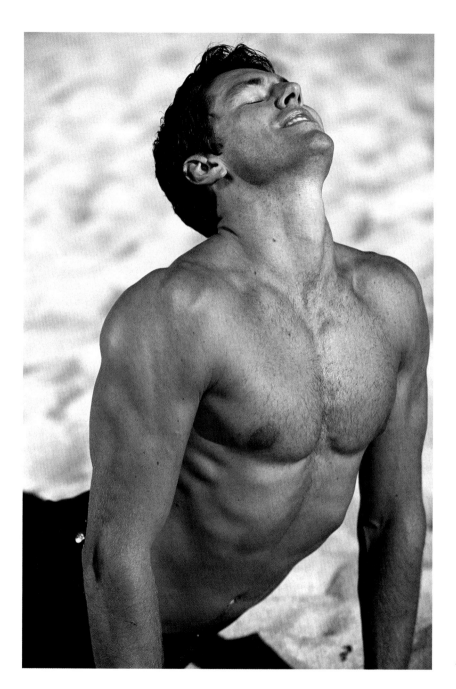

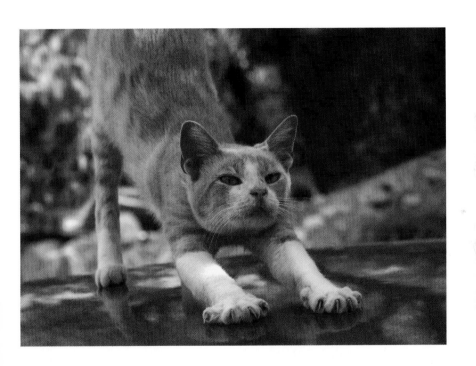

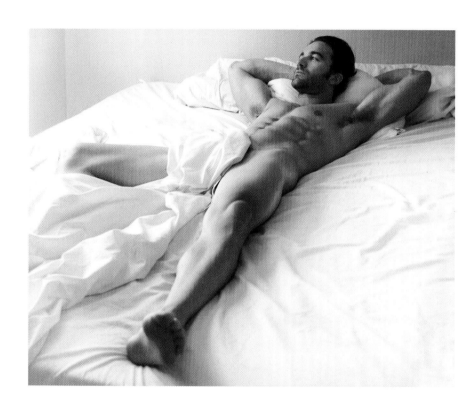

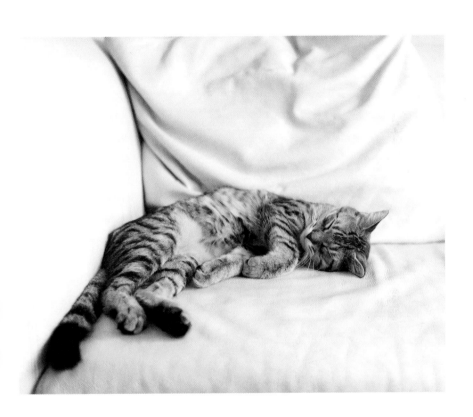

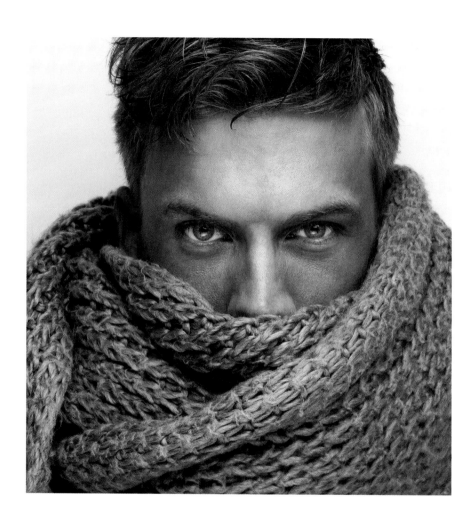

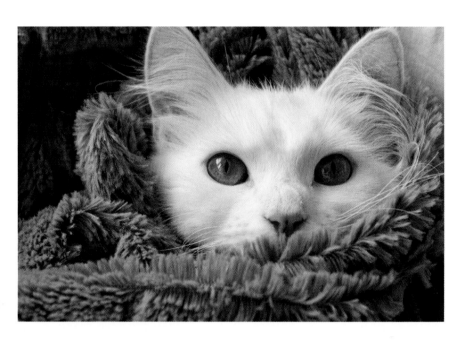

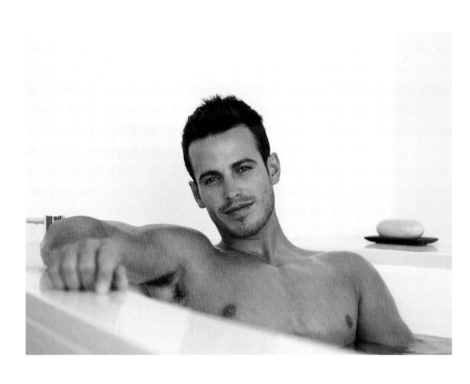

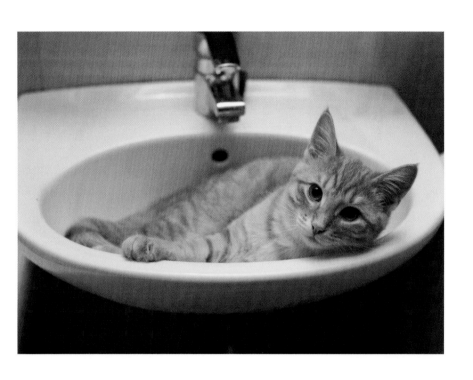

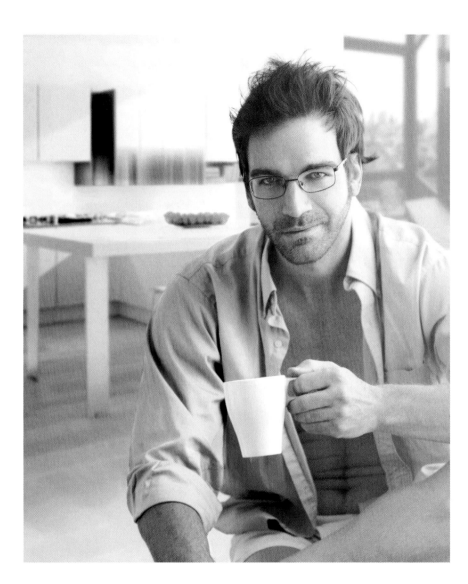

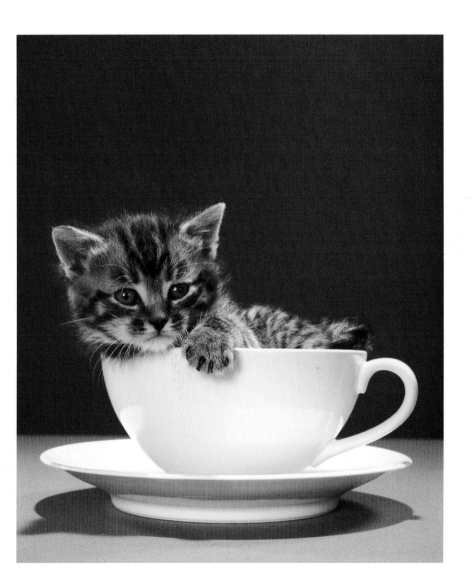

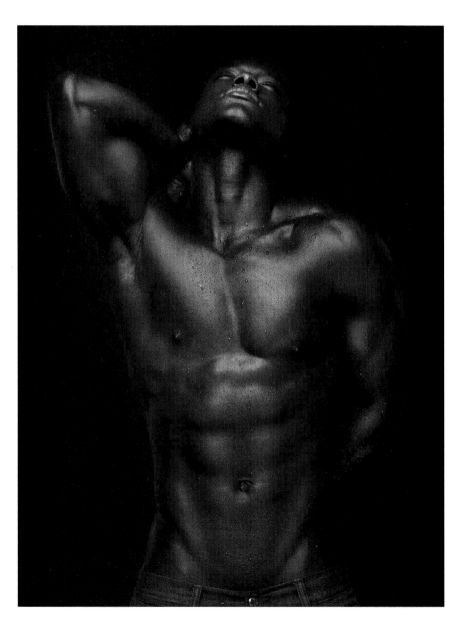

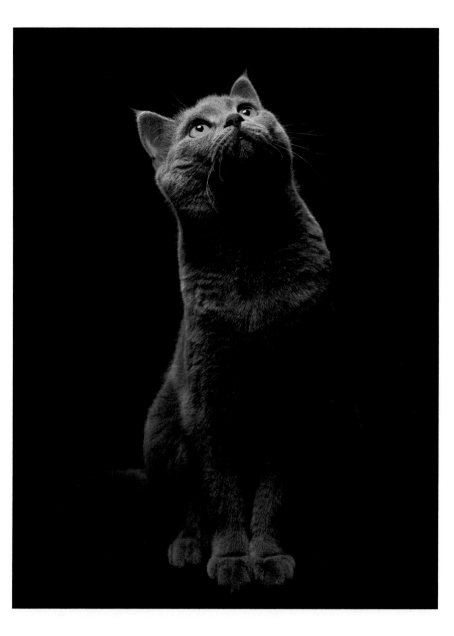

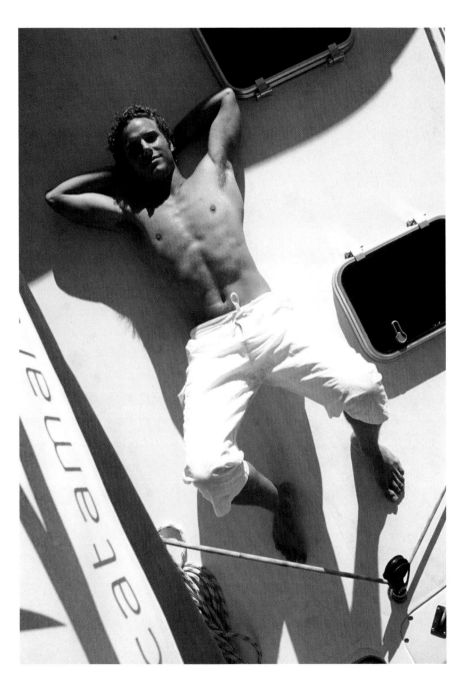

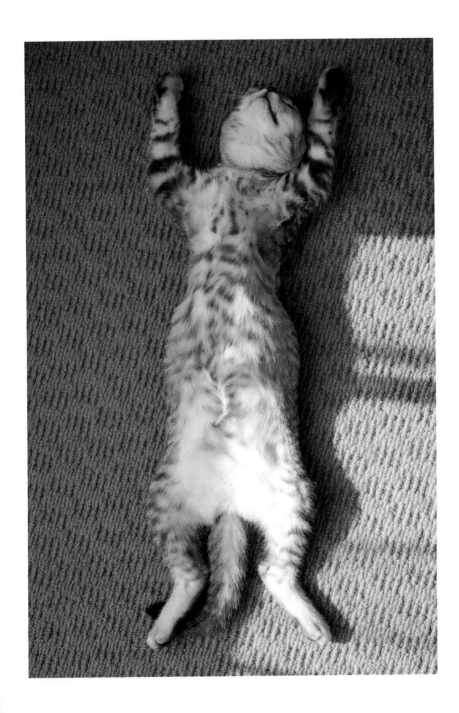

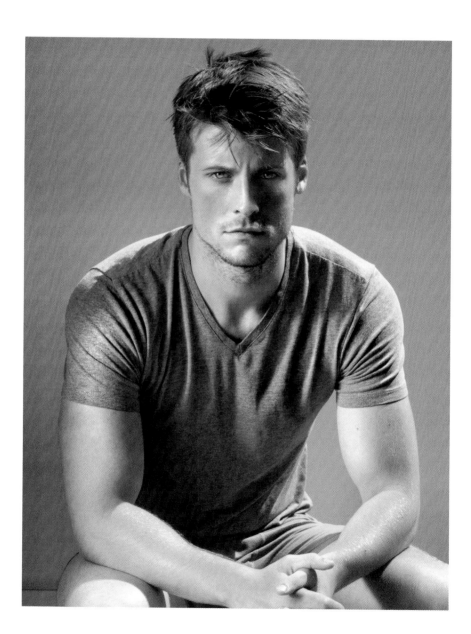

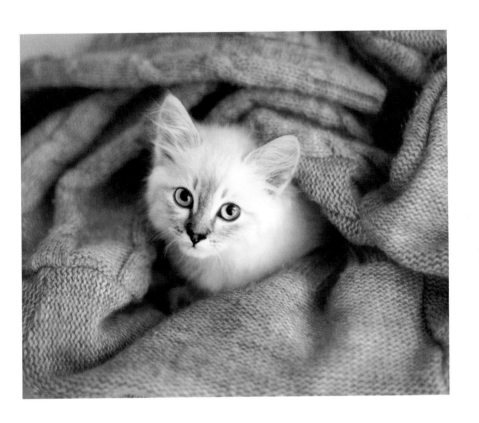

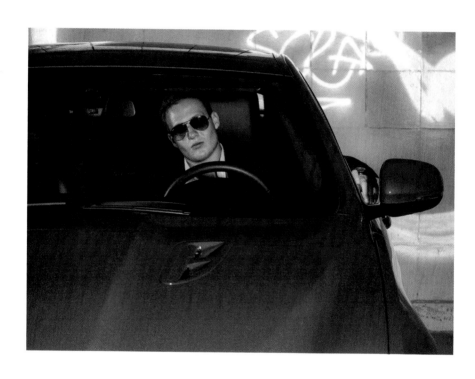

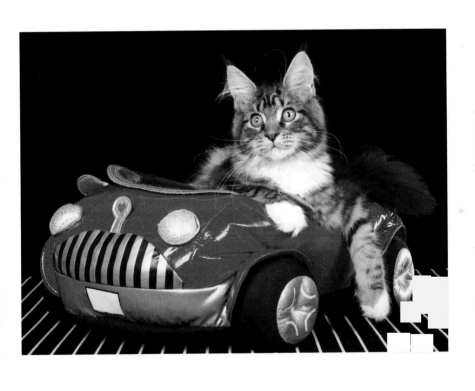

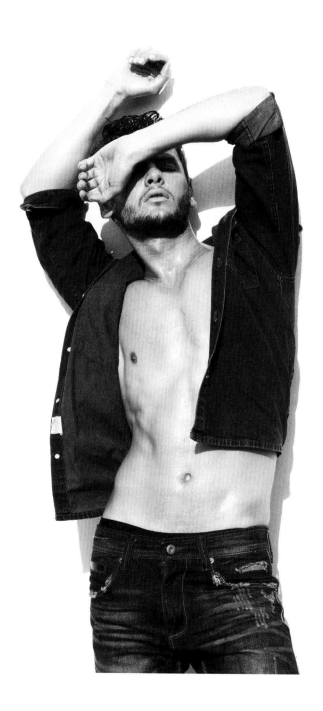

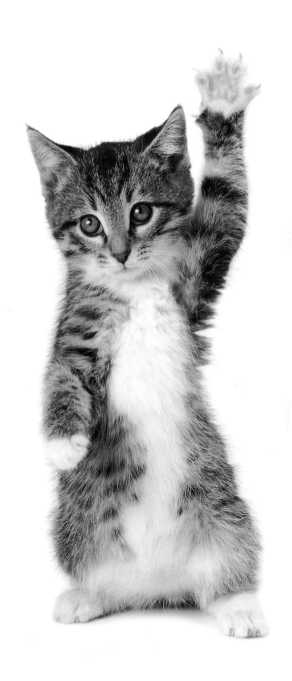

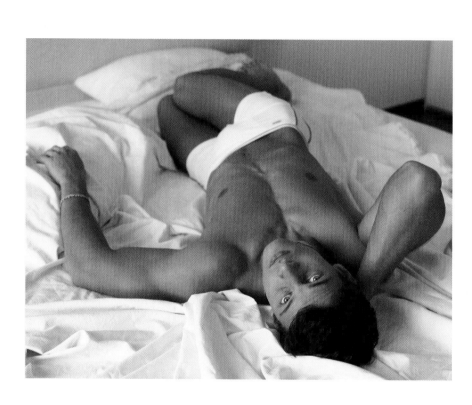

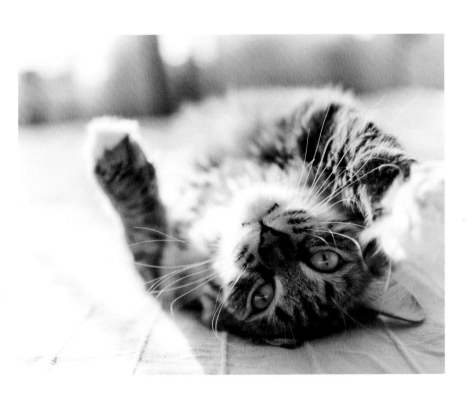

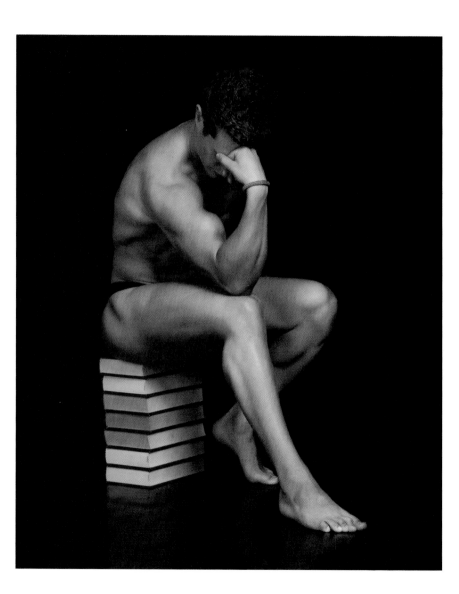

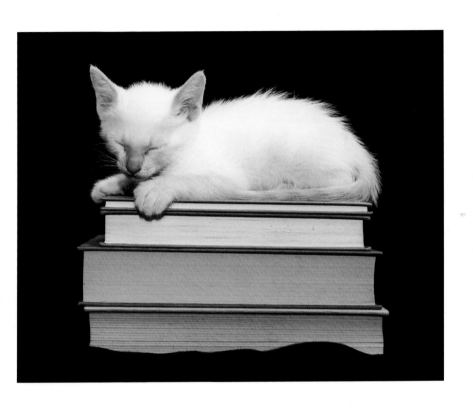

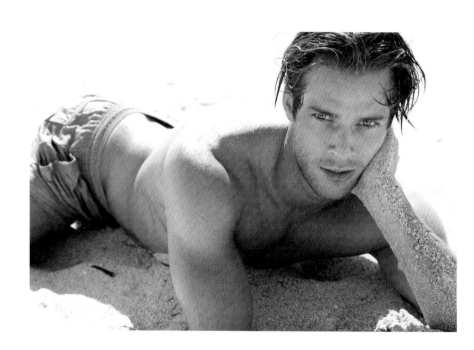

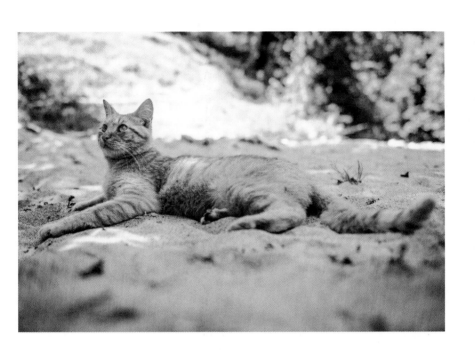

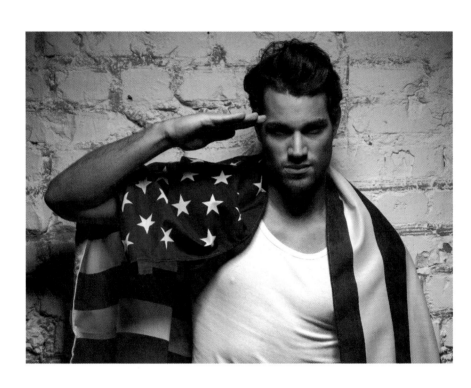

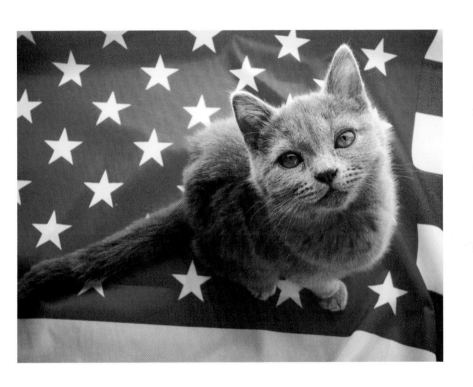

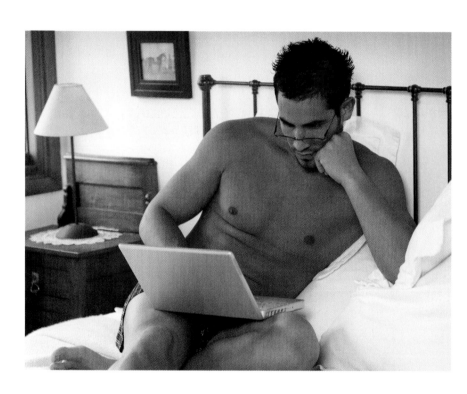

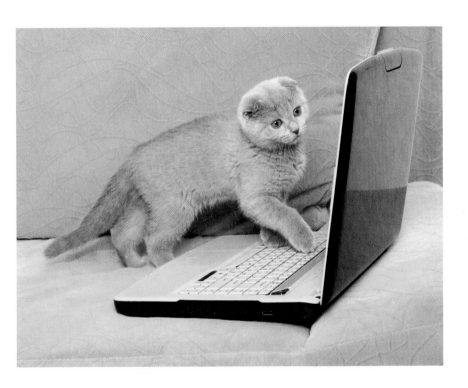

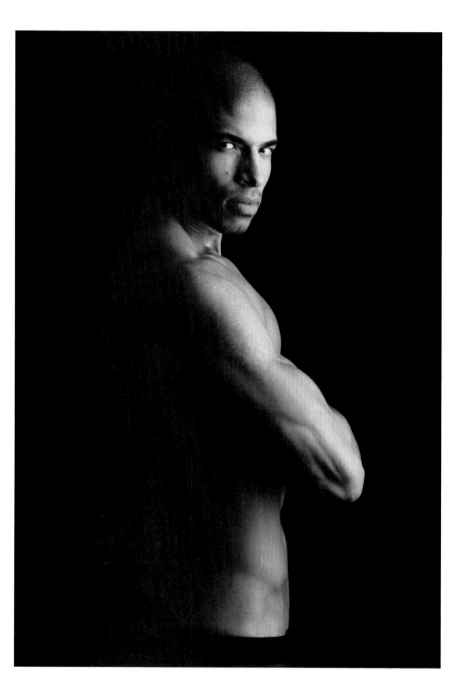

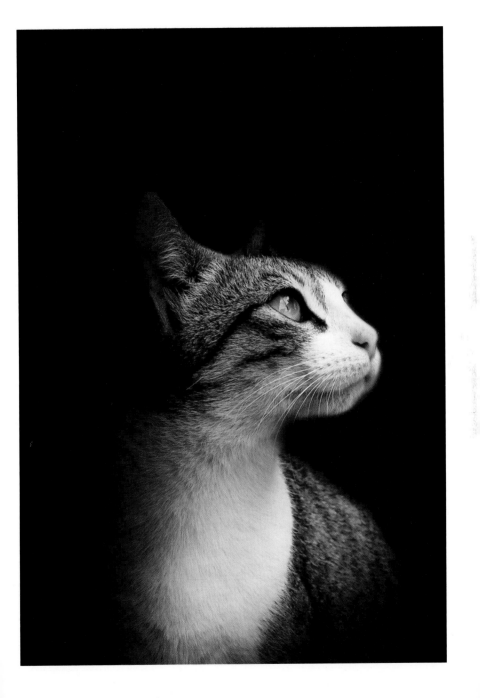

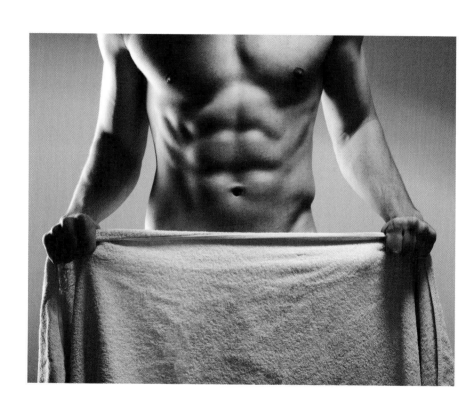

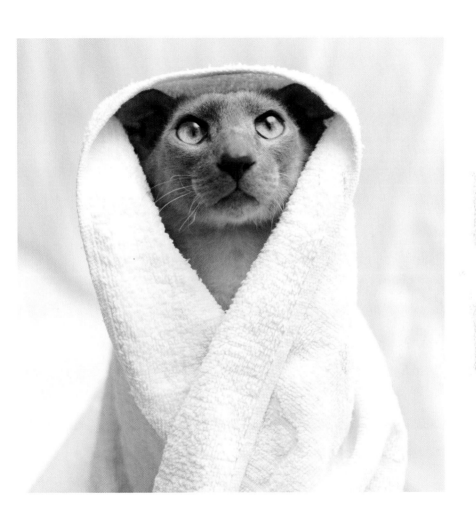

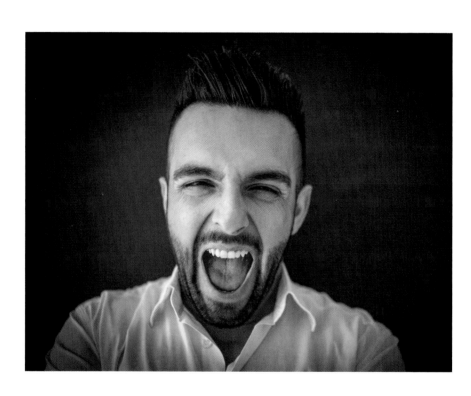

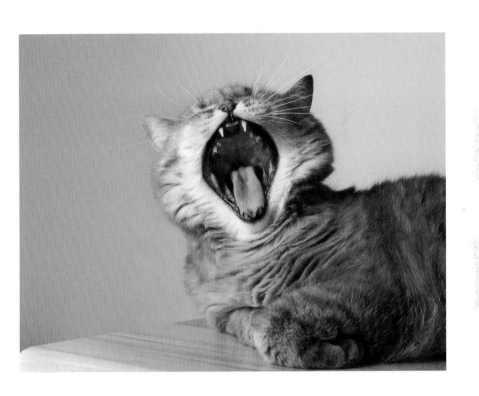

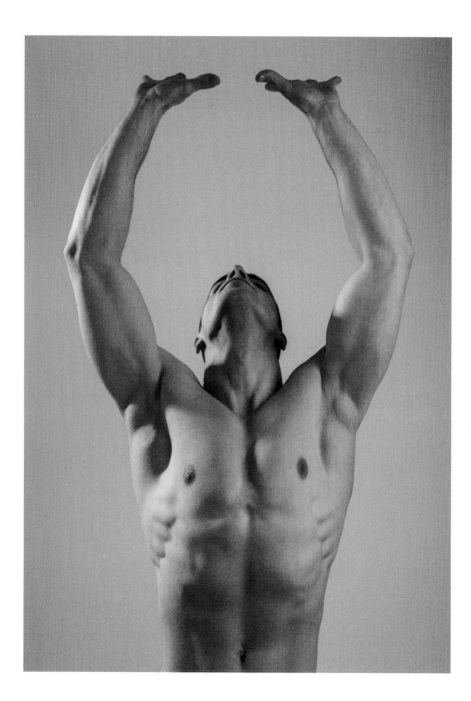

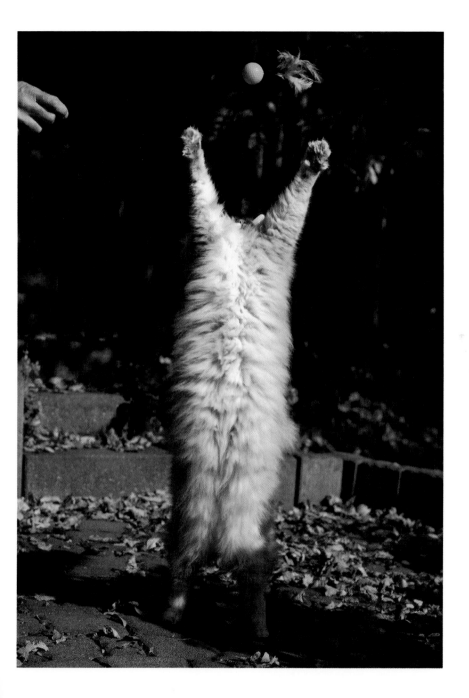

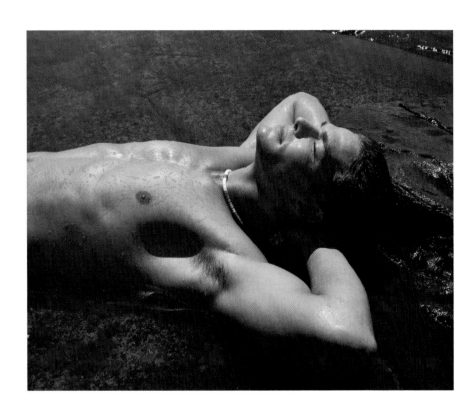

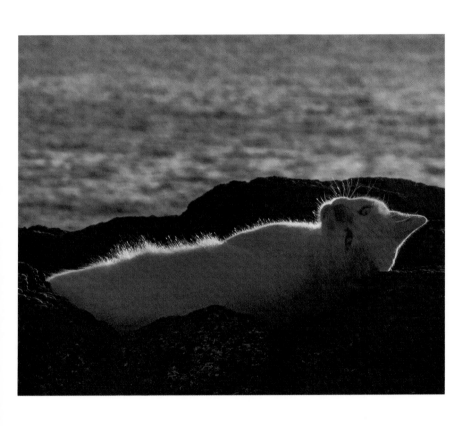

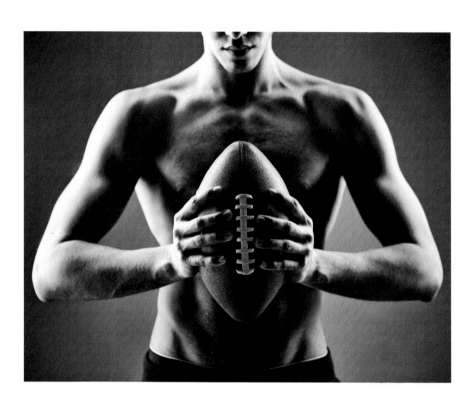

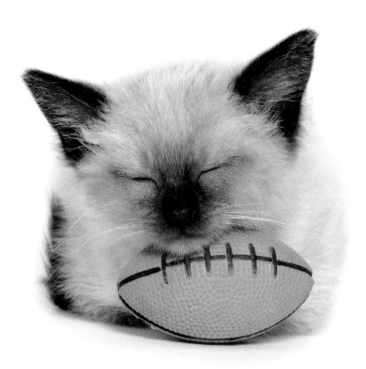

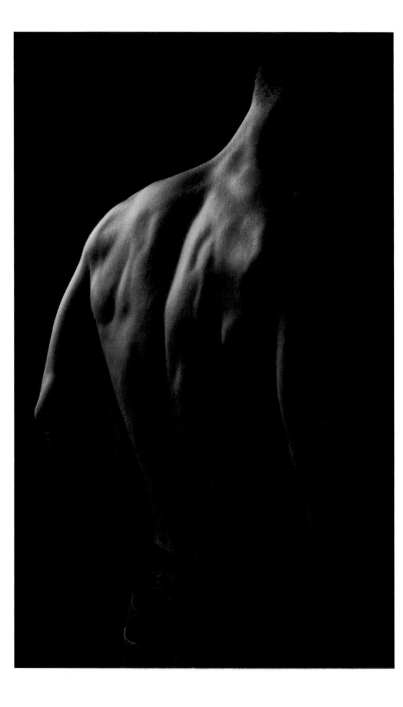

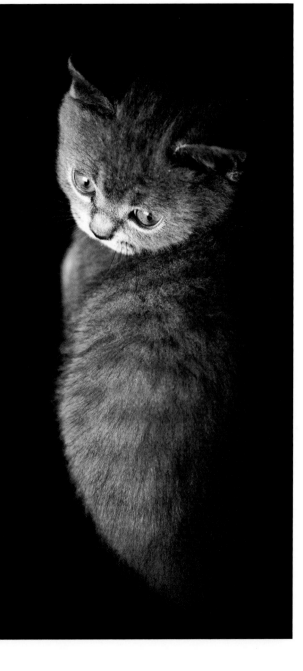

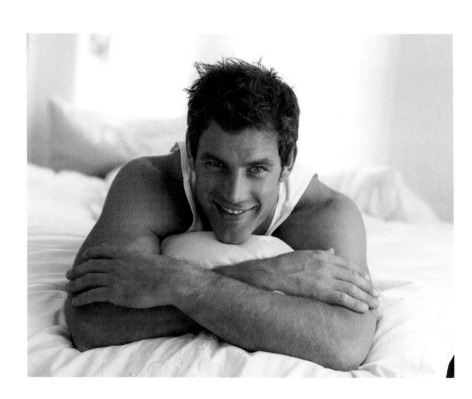

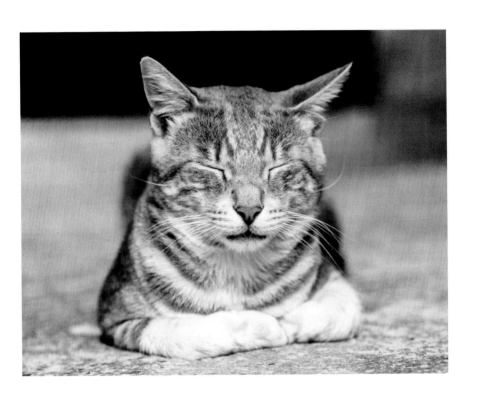

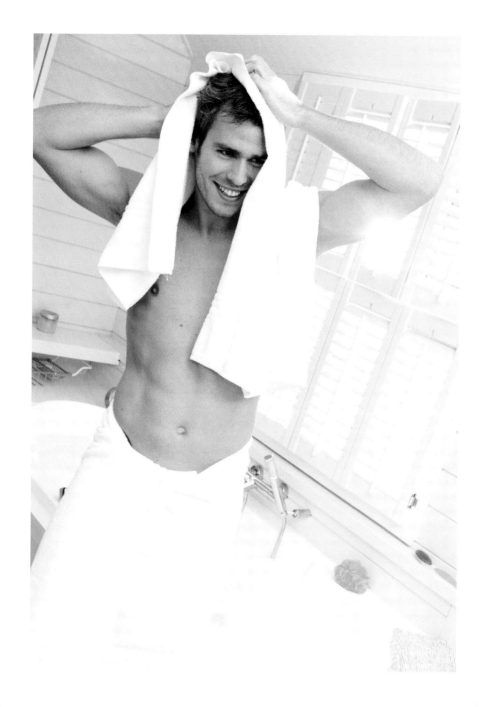

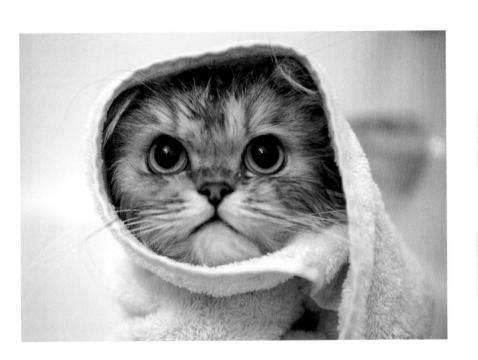

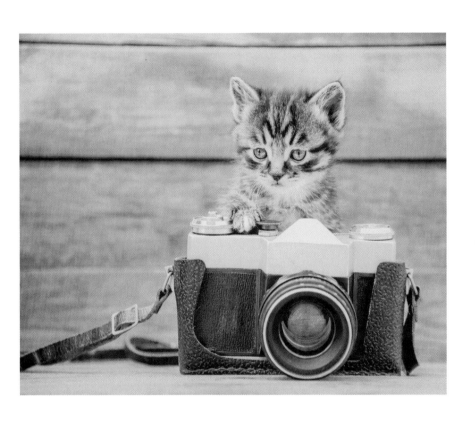

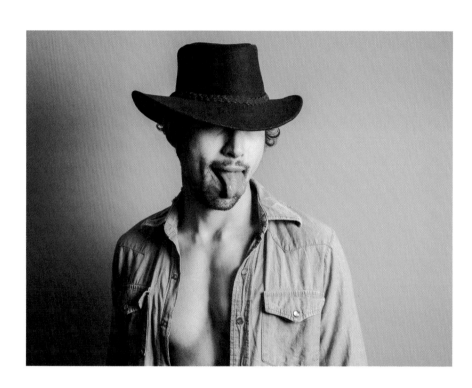

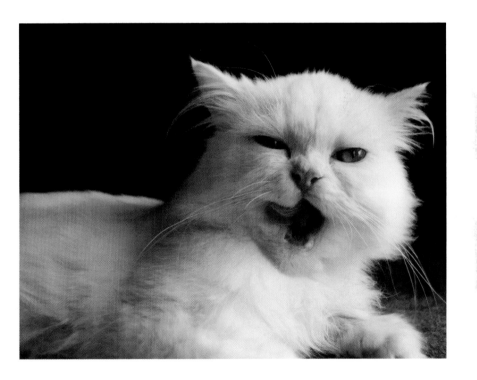

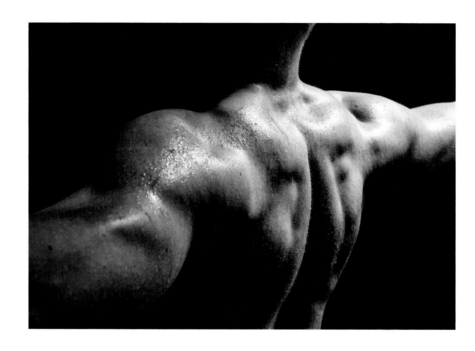

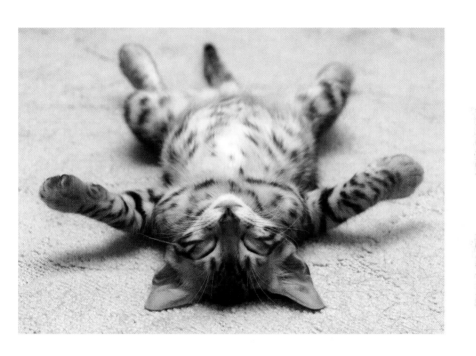

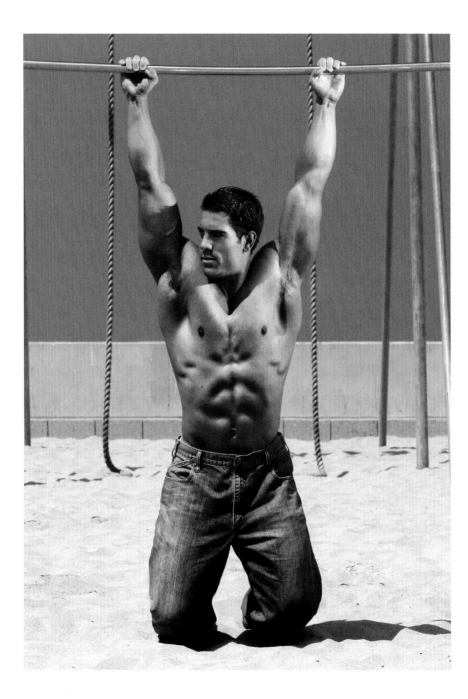

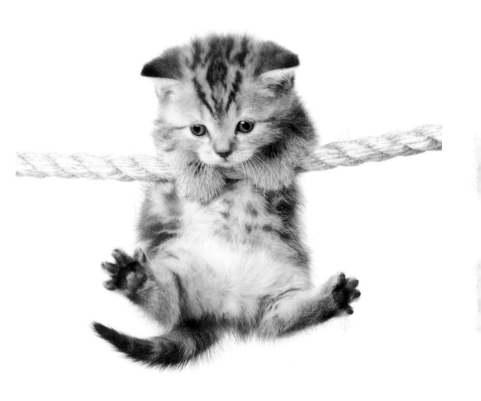

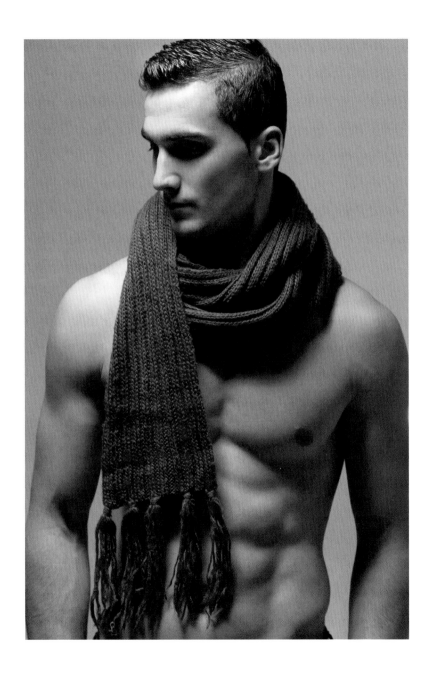

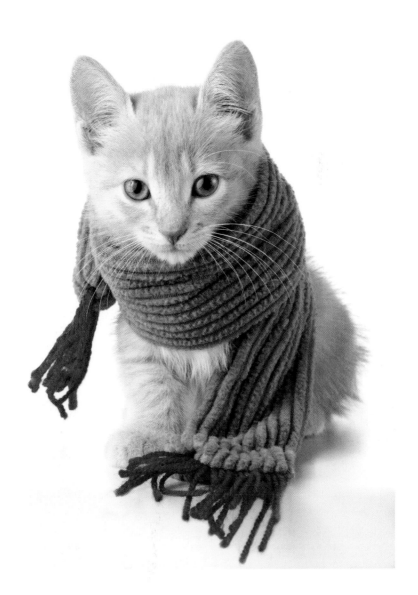

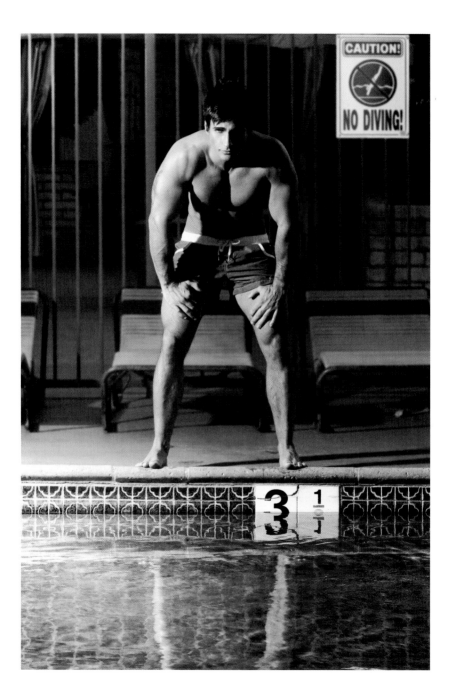

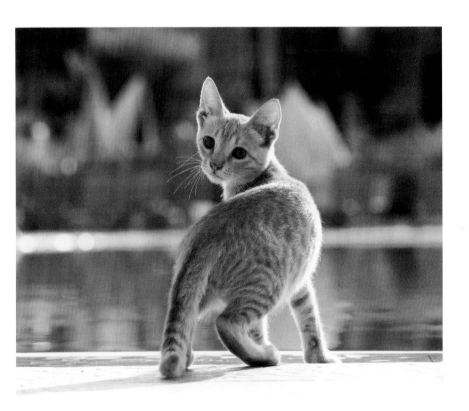

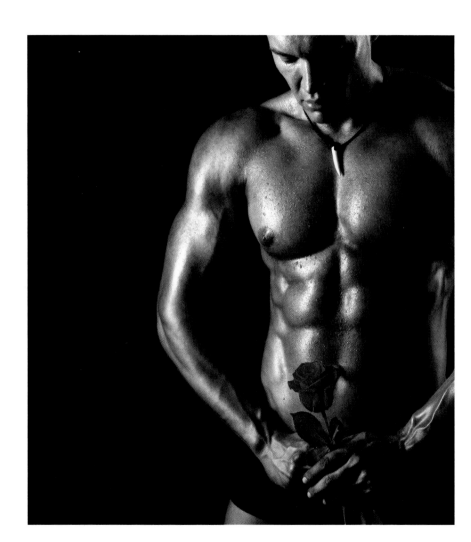

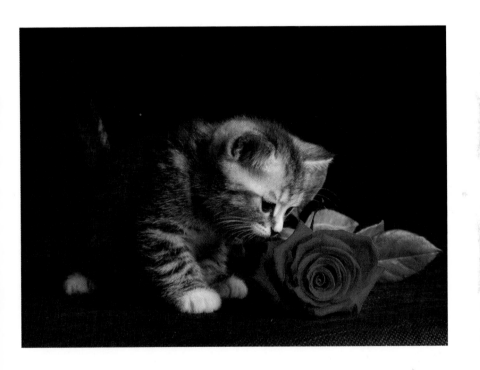

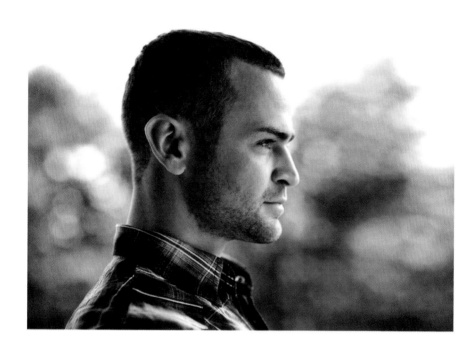

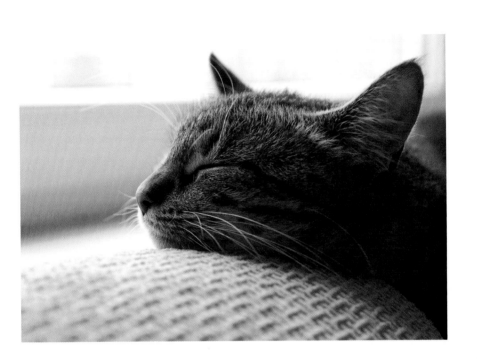

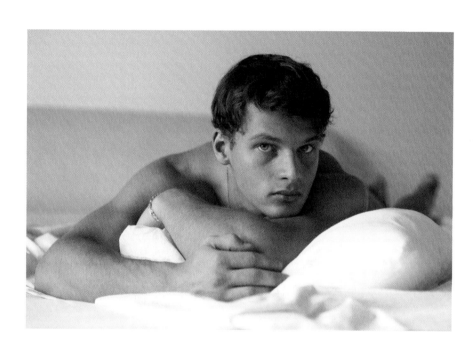

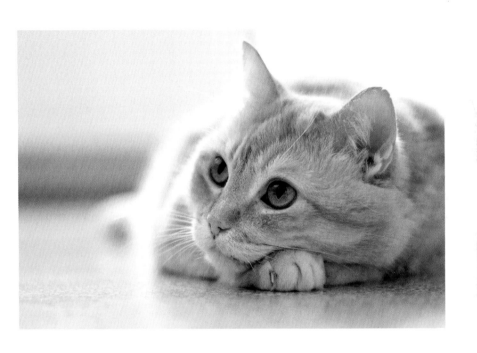

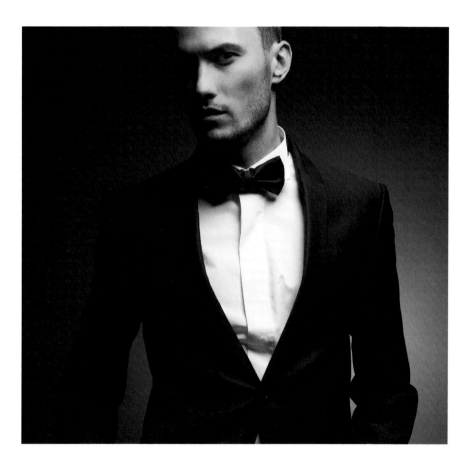

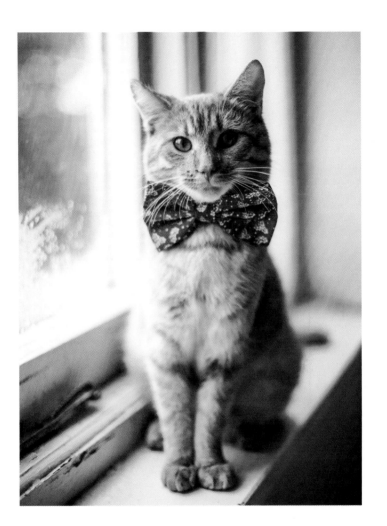

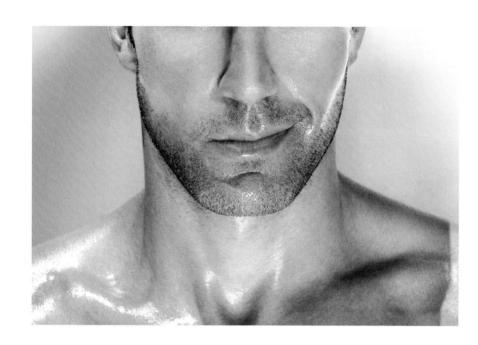

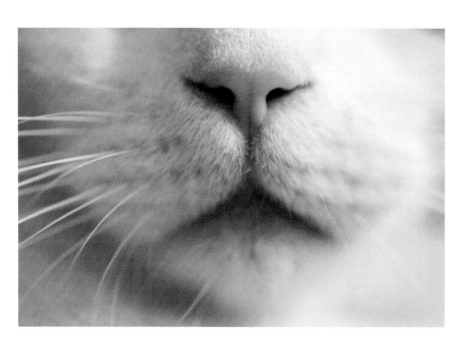

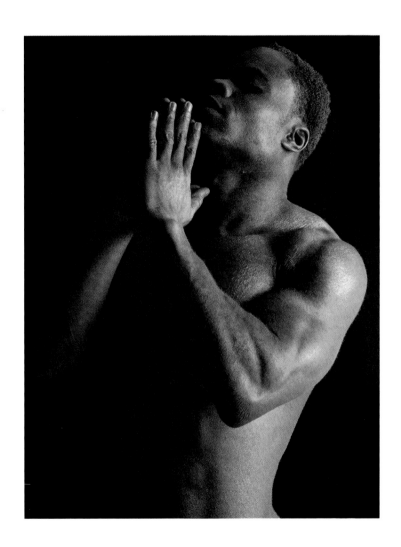

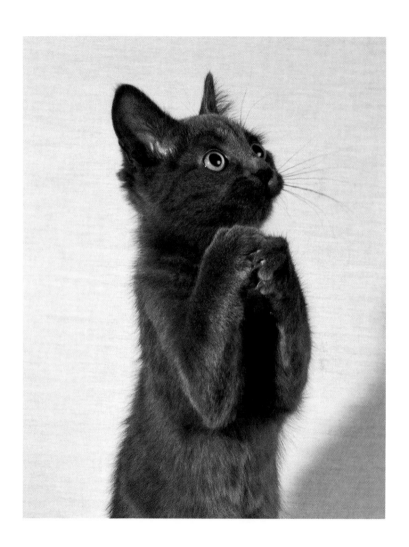

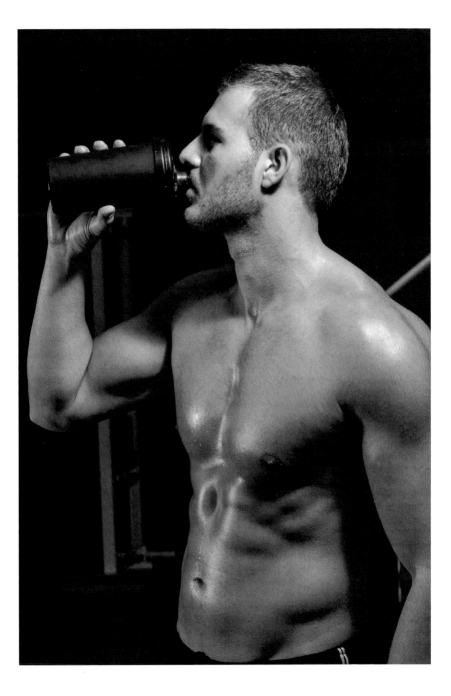

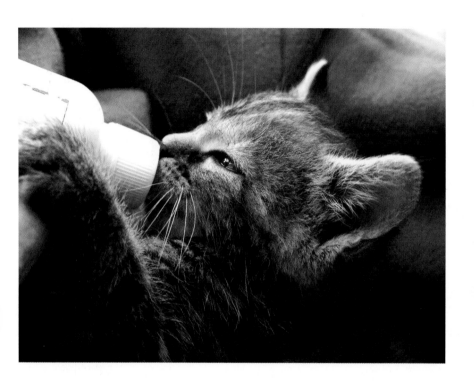

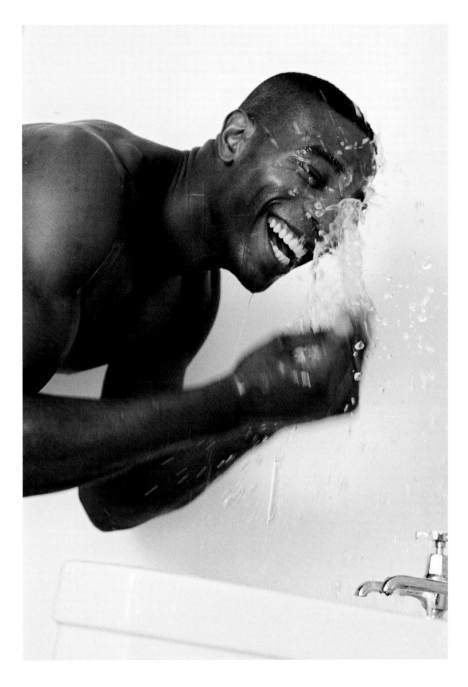

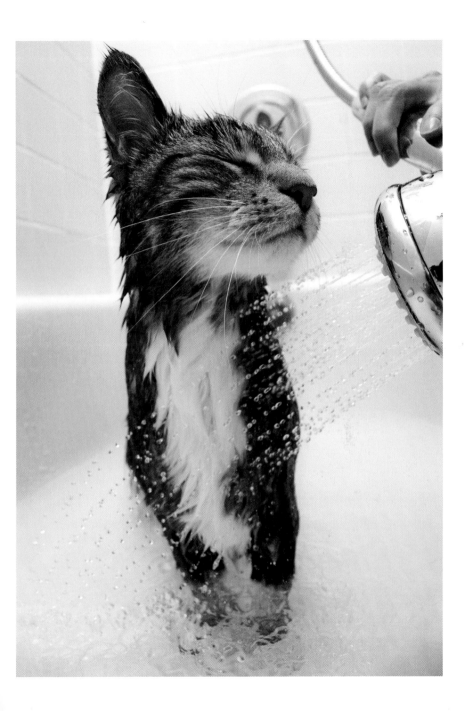

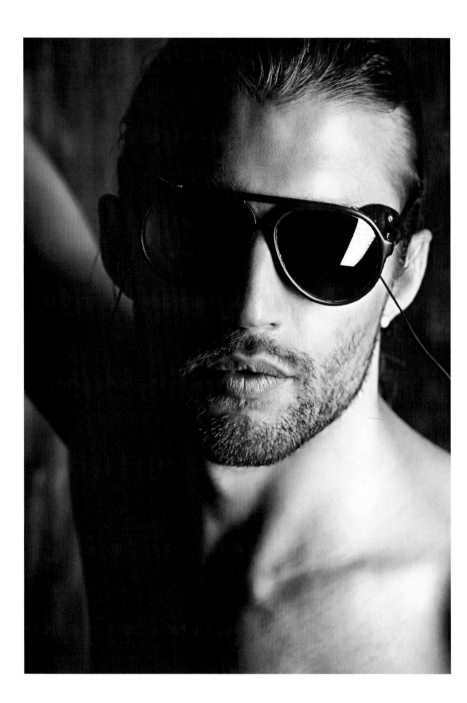

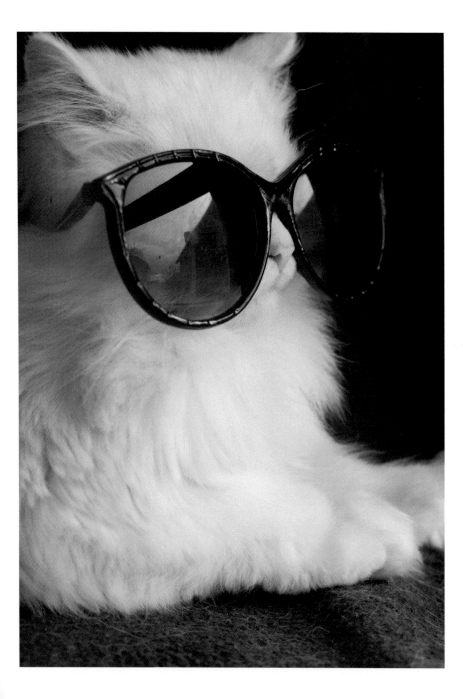

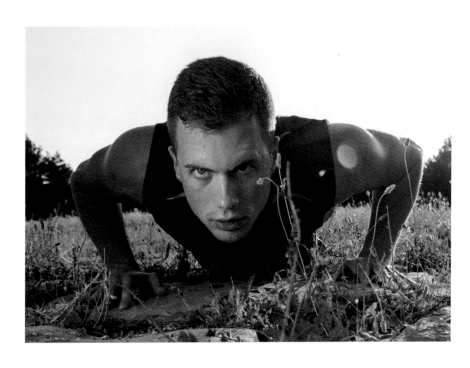

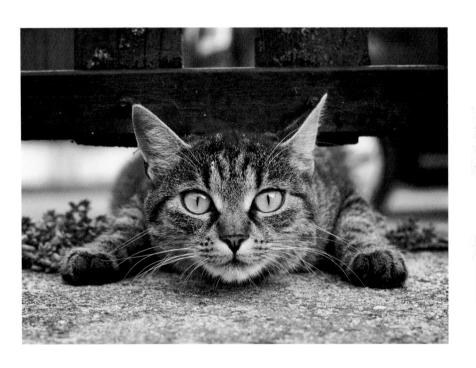

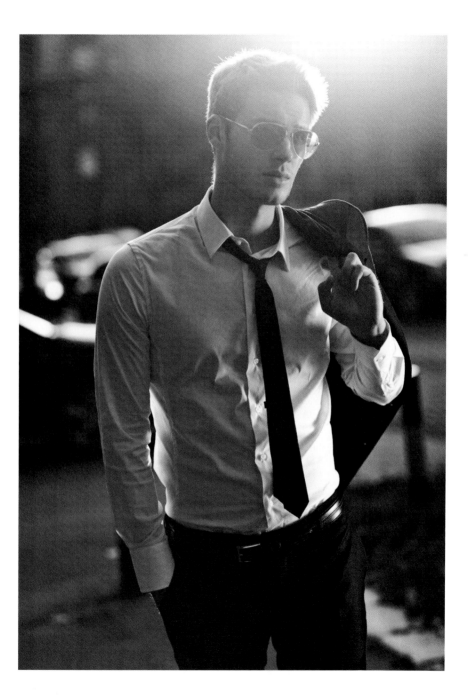

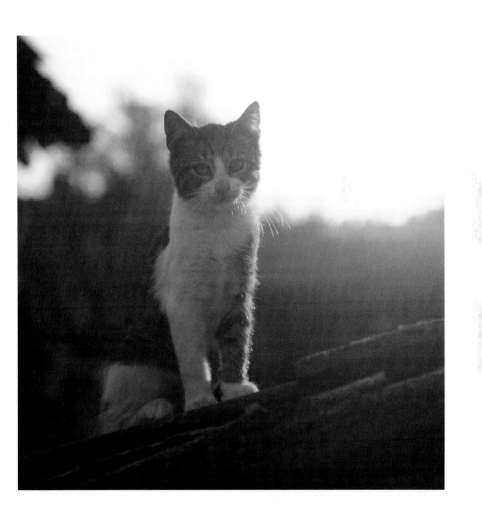

ACKNOWLEDGMENTS

We would like to thank our respective men, Michael and Simon; our pets, Diego and Crapule; and our family and friends for their daily support.

ABOUT THE AUTHORS

Marie-Eva Gatuingt and **Alice Chaygneaud** are the founders of the popular Tumblr *Des Hommes et des Chatons*, which brings their two favorite things together: kittens and men. Every day they post a pair of photos, one man and one cat, with a shared posture or attitude. Both cute and sexy, the Tumblr knows a huge and international success. Both authors live in Paris, France.